This Book Belongs To:

www.ingramcontent.com/pod-product-compliance
Lightning Source LLC
Chambersburg PA
CBHW080607220526
45466CB00010B/3282